POCKET KU-603-671

LANDSCAPE

Erika Langmuir

NATIONAL GALLERY PUBLICATIONS LONDON

DISTRIBUTED BY YALE UNIVERSITY PRESS

This publication is supported by
The Robert Gavron Charitable Trust

THE POCKET GUIDES SERIES

OTHER TITLES
Allegory, Erika Langmuir
Conservation of Paintings, David Bomford
Frames, Nicholas Penny

FORTHCOMING TITLES
Colour, David Bomford and Ashok Roy
Faces, Alexander Sturgis

Front cover and title-page:
Van Gogh, *A Wheatfield, with Cypresses*, details of 76.

First published in Great Britain in 1997 by
National Gallery Publications Limited
5/6 Pall Mall East, London SW1Y 5BA

ISBN 1 85709 168 X

525236

British Library Cataloguing-in-Publication Data.
A catalogue record is available from the British Library.
Library of Congress Catalog Card Number: 97-67663

Edited by Felicity Luard and Nicola Coldstream
Designed by Gillian Greenwood
Printed and bound in Great Britain by Ashdown Press Limited, London

CONTENTS

FOREWORD

The National Gallery contains one of the finest collections of European paintings in the world. Open every day free of charge, it is visited each year by millions of people.

We hang the collection by date, to allow those visitors an experience which is virtually unique: they can walk through the story of Western painting as it developed across the whole of Europe from the beginning of the Renaissance to the end of the nineteenth century – from Giotto to Cézanne – and their walk will be mostly among masterpieces.

But if that is a story only the National Gallery can tell, it is by no means the only story. The purpose of this new series of *Pocket Guides* is to explore some of the others – to re-hang the Collection, so to speak, and to allow the reader to take it home in a number of different shapes, and to follow different narratives and themes.

Hanging on the wall, for example, as well as the pictures, is a great collection of frames, with their own history – hardly less complex and no less fascinating. There is a comparable history of how artists over the centuries have tried to paint abstract ideas, and how they have struggled, in landscapes, to turn a view into a picture. And once painted, what happens to the pictures themselves through time as they fade or get cut into pieces? And how does a public gallery look after them?

These are the kind of subjects and questions the *Pocket Guides* address. Their publication, illustrated in full colour, has been made possible by a generous grant from The Robert Gavron Charitable Trust, to whom we are most grateful. The pleasures of pictures are inexhaustible, and our hope is that these little books point their readers towards new ones, prompt them to come to the Gallery again and again and accompany them on further voyages of discovery.

Neil MacGregor
DIRECTOR

INTRODUCTION

I f your holiday photographs have ever seemed, like mine, disappointingly flat and dull, you will know how difficult it is to turn a view into a picture. With the right film at the correct exposure, grass and trees, sky or sea, may appear more or less in their remembered colours – but the essentials of open-air experience tend to elude representation: extensive space, airy light, and, above all, our own feelings and sensations.

To represent space and light, and to communicate sensations, have been the overriding challenge of land-scape painting, in contrast to still life or portraiture, for

1. Claude, *Landscape with Psyche outside the Palace of Cupid* ('Enchanted Castle'), 1664.

example, which are more concerned with form, colour, texture and resemblance. Despite appearances to the contrary, nothing is less spontaneous than a successful landscape picture; nor does it need to refer to an actual location. There never was such a place as Claude's *'Enchanted Castle'* [1], yet an engraving after the painting inspired Keats to write about 'magic casements, opening on the foam/Of perilous seas, in faery lands forlorn.' Viewers disagree over which moment of the story of Psyche and Cupid Claude depicted – for this is Cupid's castle, and the god's mortal lover Psyche is the brooding little figure in the foreground – but few mistake the picture's elegiac tone (though no one has put this in words more shimmering than those of Keats). Drawn through dappled shade to the sunlight,

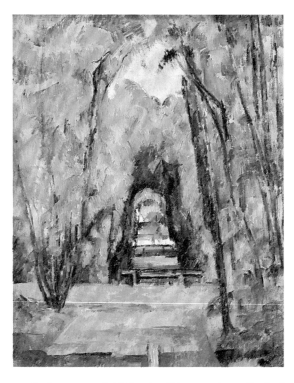

equally few can resist following Cézanne down the leafy
Avenue at Chantilly [2] – a real place, but painted more
to communicate subjective impressions than to provide
a topographical account.

When we think of landscape painting, we usually
have in mind easel pictures such as these, from the
seventeenth through the nineteenth centuries. Although
landscape was already a favourite subject of ancient
Roman mural art, this kind of 'modern' landscape is, I
believe, a genuinely new development. In the first part
of this Pocket Guide I trace its origins to the landscape
painting of fifteenth-century Venice and early six-
teenth-century Flanders. Some years before, however,
artists throughout Europe began to depict scenery in
the background of other kinds of pictures: altarpieces,
portraits and narrative paintings.

The second part of this little book illustrates the
'optics' of actual landscape and its representations. It
may be of practical help with those holiday snapshots –
but above all I hope that it enables you to visit painted
landscapes as confidently and enjoyably as real ones.
For, as we shall see, the viewer's role is crucial to both.

ORIGINS

Landscape painting, the specialised depiction of open-air vistas, has flourished above all in periods of intense urban development. City dwellers have always known, of course, that countrymen work the land to produce the staples of life, and that this work can be relentless and hard. But although aware of the utility and hardships of rural labour, townspeople have tended to view the countryside not as the site of 'the farming industry' but as a place of physical and spiritual refreshment – an effect that can be evoked in paint, whether on the walls of town houses or of country retreats.

The Latin writer Pliny the Elder, killed in the eruption of Vesuvius in AD 79, included a lengthy digression on painting and sculpture in his *Natural History* – the earliest surviving art-historical text. Here he described the activities of Studius, a Roman decorative painter of the first century BC,

who first introduced the most attractive fashion of
painting walls with pictures of country houses and
porticoes and landscaped gardens, groves, woods,
hills, fishponds, canals, rivers, coasts, and whatever
anybody could desire, together with various sketches
of people going for a stroll or sailing in a boat...
and also people fishing and fowling or hunting or even
gathering the vintage [3].

3. Landscape wall painting, first century AD. Rome, Villa Albani.

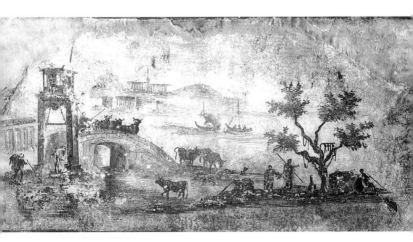

In a famous passage of his treatise on architecture, the fifteenth-century Italian polymath Leon Battista Alberti echoed Pliny, emphasising the beneficial influence of landscape painting:

Our minds are cheered beyond measure by the sight of paintings depicting the delightful countryside, harbours, fishing, hunting, swimming, the games of shepherds – flowers and verdure...

While fifteenth-century viewers, like their Roman predecessors, might be cheered and refreshed by painted landscapes, Renaissance artists were attracted to the genre for other reasons. As Leonardo da Vinci noted,

... if [the painter] wishes to produce places or deserts, or shady and cool spots in hot weather, he can depict them, and similarly warm places in cold weather. If he seeks valleys, if he wants to disclose great expanses of countryside from the summits of high mountains, and if he subsequently wishes to see the horizon of the sea, he is lord of them... (Vatican, Codex Urbinas Latinus, 5r) [4].

4. Leonardo da Vinci, *Arno Landscape*, pen and ink, 1473. Florence, Uffizi.

LANDSCAPE IN THE BACKGROUND

However proud of his ability to conjure up 'great expanses of countryside', and however many views he sketched, neither Leonardo nor any other major fifteenth-century master wished to devote his time to pure landscape painting intended merely to delight. Much later, in eighteenth-century France, when frivolity became *de rigueur*, great artists did paint ornamental landscapes on canvas to be set in the carved mouldings of a wall or atop a mantelpiece in salon or boudoir. Ripped out of their original settings, many pictures of this kind now hang in museums cheek by jowl with other easel paintings [5]. But in the more earnest fifteenth century, right-minded patrons and ambitious painters concentrated on more 'elevated' pictures designed to instruct and inspire. In practice, this normally meant religious paintings depicting Christ, his Mother, and the lives of saints and martyrs.

By the end of the century, as we shall see, this cast of mind would transform and enrich the painting of

5. François Boucher, *Landscape with a Watermill*, 1755.

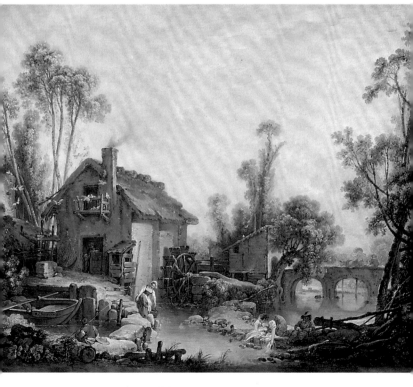

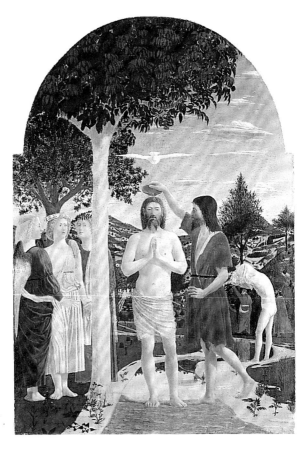

6. Piero della Francesca, *Baptism of Christ*, 1450s.

landscape itself – but in the Early Renaissance artists who wished to create 'great expanses of countryside' incorporated them in overtly religious images. They replaced with landscapes the traditional glittering gold-leaf backgrounds of altarpiece panels. Besides reducing costs – for gold leaf was made by beating out gold coins, and its application was slow and laborious – this procedure had a number of conceptual advantages.

Most notably, the addition of landscape backgrounds transformed altarpieces from luxurious items of church furniture into windows on another world, analogous to our own. Those who could see them on the altar became in some sense the witnesses of an actual event. The greater naturalism of a landscape setting could almost vouch for the historical veracity of the holy scene and personages portrayed.

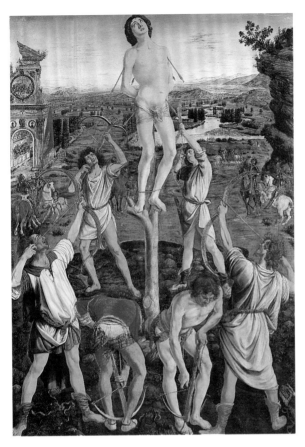

7. Antonio and Piero del Pollaiuolo, *Martyrdom of Saint Sebastian*, completed 1475.

Landscape backgrounds at this time, however, did not normally depict first-century Palestine or the Syrian desert, but locations familiar to the painter and his contemporaries. In Piero della Francesca's *Baptism of Christ* of the 1450s [6] the River Jordan is made to flow through a carefully observed Tuscan landscape near Borgo San Sepolcro, for the altar of whose Camaldolese abbey the painting was commissioned. The setting emphasised both the local devotion to Saint John the Baptist and the universality of the sacrament of baptism.

A similar point was made in the altarpiece of *The Martyrdom of Saint Sebastian* painted in 1475 for the Florentine Oratory of Saint Sebastian by the Pollaiuolo brothers [7]. The saint is raised high above the valley of Florence's river, the Arno, although an incongruous Roman triumphal arch recalls the date of his ordeal under the Emperor Diocletian.

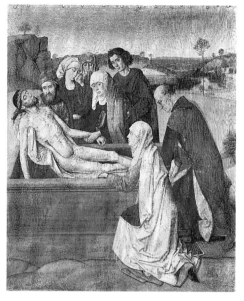

Mourners grieve over the dead Christ in front of the rolling countryside of Belgium in Dieric Bouts' *Entombment* [8], a fragment of an altarpiece painted in the 1450s. The realistic setting helps the viewer to empathise with the grieving figures. It also, however, serves to extend the picture's historic and symbolic significance, for the tender green of springtime marks the season of Christ's Passion, and symbolises the Resurrection to come.

Solemn meditation rather than empathy is encouraged by Leonardo's *Virgin of the Rocks* [9]. Based on a composition of the 1480s now in Paris, it was painted in 1508 for the altar of a Milanese confraternity devoted to the Immaculate Conception. Kneeling and seated figures are grouped in a watery grotto, its floor overgrown with vegetation. Inspired by a legend of the infant Baptist meeting his cousin Jesus in the wilderness during the Flight into Egypt, Leonardo's personages have slipped their narrative moorings. Their actions and expressions now recall key concepts of Christian doctrine: the Incarnation; Mary's compassionate intercession;

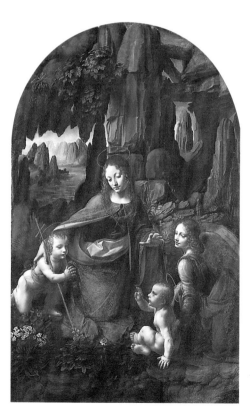

the power of prayer. The cycle of emotions circulating among them, and the cycle of man's redemption, are echoed in the cyclical process of nature – the evaporation and condensation of water – suggested by the landscape setting.

Leonardo's scientific bent not only led him to depict the effect of linear perspective through the diminution of the rocks beyond the grotto, but also that of aerial perspective, which gradually causes them to change colour, following his own precept:

...you should represent the air as rather dense. You know that in such air the furthest things seen in it – as in the case of mountains, when great quantities of air are found between your eye and the mountains – appear blue, almost the colour of the air when the sun is in the east. Therefore make the first building...of its own colour; the next most distant make less outlined and more blue; that which you wish to show at yet another distance,

8 (opposite). Dieric Bouts, *The Entombment*, probably 1450s.

9. Leonardo da Vinci, *The Virgin of the Rocks*, about 1508.

make bluer yet again; and that which is five times more distant make five times more blue. This rule ensures that when buildings appear of equal size above a line [as, here, the furthermost mountains above the edge of the water], it will be clearly discerned which is more distant and larger than the others (Codex Urbinas, 78r–v) [10].
Sounding a less portentous note, Memlinc's *Triptych* of

10. Detail of mountains in 9.

11. Detail of 12, left side of centre panel.

12. Hans Memlinc, *The Virgin and Child with Saints and Donors (The Donne Triptych)*, probably about 1475.

about 1475 was once the focus of the Donne family's private devotions to the Virgin and Child and to their patron saints [12]. Memlinc's Queen of Heaven receives her guests in a loggia open onto a sunny country estate. The view delights in much the same way as a walk in the countryside provides escape from daily cares. Background motifs integrate light-heartedly with the figures in the foreground: the wheel of Saint Catherine's martyrdom has magically become a mill-

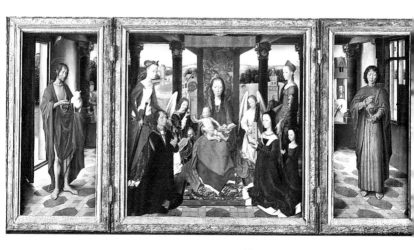

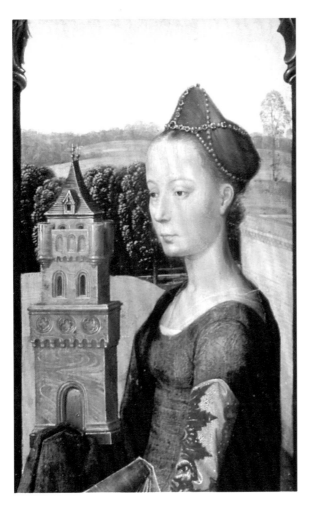

wheel in the distance [11], and the tower where Saint Barbara was imprisoned by her cruel father can be read as either a toy-like miniature in her hand or a full sized edifice in the meadow behind [13]. Landscape, for Leonardo and Memlinc, becomes an emblem of Salvation – but where Leonardo's cavern inspires awe, Memlinc's rural vision exemplifies the spiritual refreshment of religious observance.

13. Detail of 12, right side of centre panel.

If religious painting was the highest form of art in this period, portraits recording the appearance of important people, or commemorating special events such as betrothals, were nearly as important.

From the 1400s painters often depicted their sitters silhouetted against flowering shrubs and hedges, like those in tapestries, or against the sky. The idea of situating a portrait in front of a spacious landscape seems to have been adapted from religious imagery; many devotional works, like Memlinc's *Donne Triptych*, already included portraits of pious 'donors'.

14 Dieric Bouts,
The Virgin and Child,
about 1460.

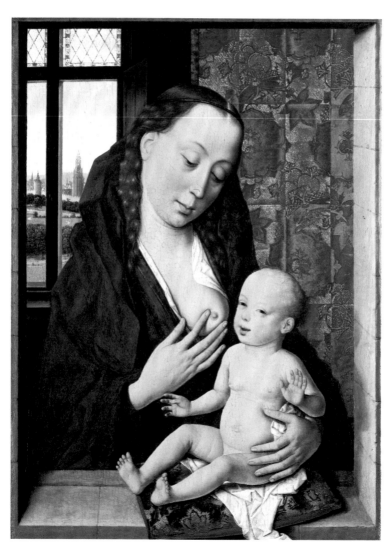

15. Dieric Bouts,
Portrait of a Man,
1462.

Memlinc in The Netherlands and Piero della Francesca in Italy executed the earliest-known portraits with a landscape background. They were outdone by Leonardo da Vinci in the most famous portrait of all, the *Mona Lisa,* now in the Louvre, in which the unknown lady is seated on an improbably high balcony overlooking a fantastical panorama.

An especially popular portrait formula invented in The Netherlands placed the sitter more logically in a room lit by a window framing a distant view. Two paintings of the 1460s by Dieric Bouts show the relationship of this type of portrait to devotional images [14, 15].

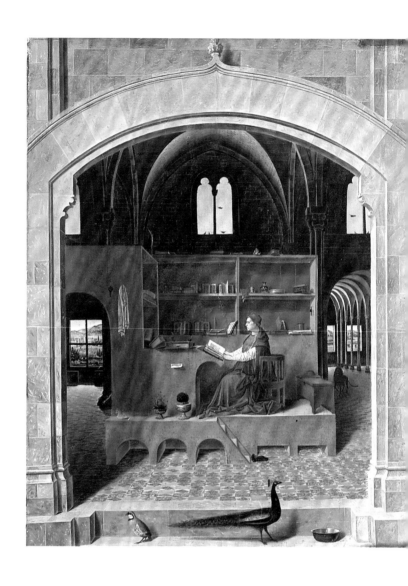

16. Antonello da
Messina,
*Saint Jerome in
his Study,*
about 1475.

17. Detail of
landscape in 16.

The supreme example of the fifteenth-century 'land-
scape seen through a window', however, must be
Antonello da Messina's *Saint Jerome* [16], which may
portray a contemporary cardinal in the guise of the
scholar saint. With its minuscule views of skies, mead-
ows, river, hills and walled town seen framed in the
windows behind Jerome's study [17] no picture better
evokes the charm of outdoor vistas for those who spend
their working life indoors.

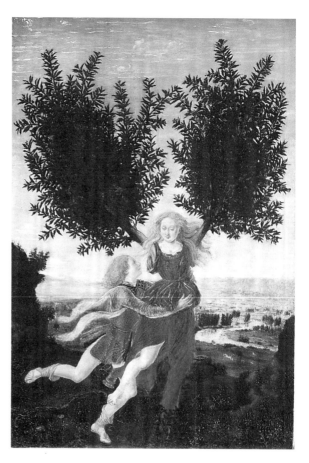

With some notable exceptions, fifteenth-century pictures of mythological subjects were executed on a small scale as domestic decoration. Most of them were based on the Latin poet Ovid's *Metamorphoses*, a verse compilation of ancient legends invented to explain the manifold phenomena of nature; landscape was thus an inevitable component of the theme. Nonetheless, perhaps because of their association with classical literature and their supposed didactic function, artists tended to treat these secular works after the fashion of their religious compositions: figures in the foreground, landscape as background.

Antonio del Pollaiuolo's *Apollo and Daphne* of about 1470–80 [18], a small panel probably once part of a piece of furniture, depicts the nymph's flight from the sun god and the victory of chastity over desire. Cupid's malicious darts have caused a tragic imbroglio: a

22

golden arrow shot at Apollo has aroused his passion for Daphne, a leaden one aimed at Daphne has caused her to detest him. She escapes his pursuit by changing into a laurel tree. We are shown the very moment of her metamorphosis, as she waves her leafy limbs on a promontory high above a miniature version of the landscape in Pollaiuolo's *Martyrdom of Saint Sebastian* [7].

In about 1495, the animal-loving Piero di Cosimo pictured a half-human satyr and a mournful dog grieving over another ill-fated nymph on a long panel which may have formed the footboard of a nuptial bed [20]. The picture's literary source, never satisfactorily identified, may have been the tale of Cephalus and Procris, a warning against unfounded jealousy between husband and wife. Adapting his composition to the awkward format, Piero interpreted Leonardo's recipe for aerial perspective to paint a blue lake and its furthest shores in tones as delicate as those on a Chinese willow-pattern plate [19].

19. Detail of 20.

20. Piero di Cosimo,
A Satyr mourning over a Nymph,
about 1495.

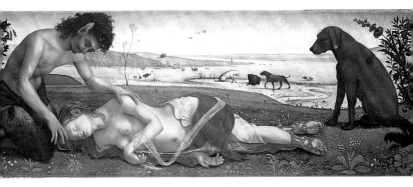

FIGURES AND LANDSCAPES
INTEGRATED

These fifteenth-century pictures keep the spectator at a distance from the scenery. Some of them even put up imaginary 'No Trespassing' signs, by making foreground figures appear in a space unconnected to their landscape backgrounds, or by showing figures and backgrounds from different viewing points and separately illuminated. These works include landscape as an optional extra. It may help locate a scene or figure, or extend its significance, or increase its immediacy, but the real business of the picture is with the figures, not the landscape.

Certain narrative subjects, however, are difficult to grasp without a closer integration of the two – such as the story of Saint John the Baptist retiring into the desert, depicted around 1453 on this small predella panel by the Sienese Giovanni di Paolo [21]. Normally visible only to the officiating priest, predella paintings, decorating the box-like structure supporting the altarpiece on the altar table, were often the site of pictorial experiments.

The youthful Baptist's progress is suggested by showing him twice, both times in profile as if moving forward from left to right, impelled by diagonal lines. While he remains constant in size, landscape elements diminish the further they are from him: the handkerchief patches of fields and the dolls' buildings in the

21. Giovanni di Paolo, *Saint John the Baptist retiring to the Desert*, probably about 1453.

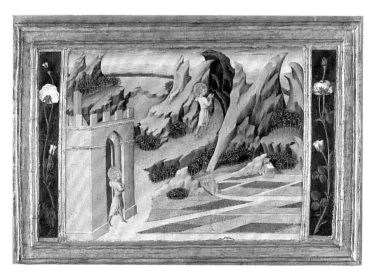

foreground are smaller than either the city gate in the same plane or the rocky crevice near the top of the panel.

This organisation of space adapts a perspective system pioneered, over a century earlier, by Ambrogio Lorenzetti in the vast mural frescoes of *Good and Bad Government* in Siena town hall. On this small panel Giovanni reinterprets Ambrogio's method playfully, to give a fairy-tale, ornamental flavour to the story rather than to evoke the viewer's actual experience of voyaging through space and time.

Landscape is also an integral component of the stigmatisation of Saint Francis, a key scene in Franciscan imagery. Observed at some distance by Brother Leo, Francis fell into ecstasy while praying in the open air in the mountain wilderness of La Verna. The crucified Christ, in the semblance of a fiery seraph, appeared to him in the sky, miraculously imprinting his own wounds, or stigmata, on Francis's body.

Sassetta's small painting of this subject [22] is a fragment from a compound altarpiece completed in 1444. The picture was one of eight scenes from the life of the saint surrounding his large-scale image – in spirit, if not in function, identical to the narrative panels of predellas. Sassetta, like Giovanni di Paolo,

22. Sassetta,
*The Stigmatisation
of Saint Francis*,
1437–44.

was Sienese, and was also influenced, to more dramatic effect, by the landscape experiments of the Sienese fourteenth-century masters.

Although the figures of Saint Francis and Brother Leo loom large in the foreground, out of scale with the rocks and chapel in the background, Sassetta has integrated figures and landscape by illuminating both with the supernatural light emanating from the seraph, attesting to the miracle whereby Francis becomes 'another Christ'. The power and direction of the light are shown most clearly through the shadows it creates: note especially the one cast by Francis's splayed fingers raised above his shoulder, the shadow of his rope belt on his tunic, or that of the rocks staining the façade of the chapel. Since the source of light is in the background, Brother Leo's shadow is cast forwards, onto the rocky ledge in the foreground.

THE EXPRESSIVE LANDSCAPE

FIFTEENTH-
CENTURY
ORIGINS

Some twenty years later the Venetian painter Giovanni Bellini was to take a more momentous step in integrating figures, outdoor space and illumina-

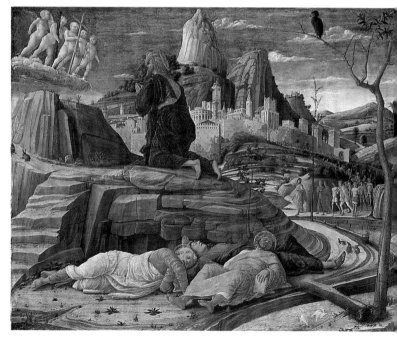

tion in religious painting – a step that was, I believe, crucial to the transformation of pure landscape from a minor decorative genre to a major expressive one.

The episode of Christ's agony in the garden, immediately preceding his capture and trial, shows him at prayer in the Garden of Gethsemane, the disciples sleeping 'about a stone's cast' from him, and the soldiers, led by Judas, approaching from the direction of Jerusalem (Matthew 26:36–47; Luke 22:39–47).

Both Bellini's version of this scene and that painted by his brother-in-law Andrea Mantegna some five years earlier [23] were probably inspired by predella panels, but their larger size suggests that they were painted for private contemplation, midway between devotion and aesthetic enjoyment. Mantegna constructed a tightly knit landscape in which continuity is visually implied – through a series of light and dark curves – between the road winding out from Jerusalem and that skirting the barren mound on which Christ kneels in prayer, as at a rock-hewn open-air altar.

Bellini's *Agony in the Garden* [24] opens out Mantegna's composition into a gentler, more contemplative image. Locating the biblical story among the hill towns of northern Italy, Bellini also set it at dawn

24. Giovanni Bellini, *The Agony in the Garden*, about 1465.

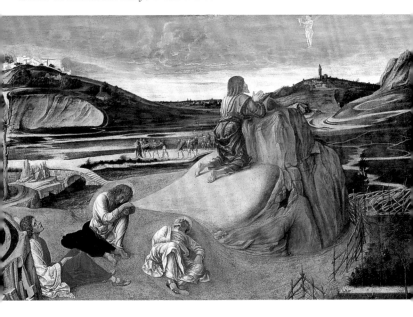

rather than the earlier hour specified in the texts. The painted Christ has prayed in anguish the whole night through, while the wearied and sorrowful disciples who would watch with him have fallen asleep. Now is the moment of resolve – 'the hour is at hand, and the Son of man is betrayed into the hands of sinners' (Matthew 26:45) – and of reconciliation: 'Not my will, but thine, be done' (Luke 22:43). The innocent victim consents to drain the bitter cup; the work of Salvation is assured.

The light from the rising sun invests the entire picture with a glow at once naturalistic and symbolic. It makes explicit what is already implied in the composition: the unity of the landscape inhabited by the figures, and its openness to the viewer's gaze. Despite their still disproportionately large scale, Christ and the disciples do not bar us from wandering in our imagination through the fluidly disposed, rounded planes and meandering pathways from foreground to background. The mass of clouds, its underside reflecting the rosy-orange light, appears to lie over, and not merely behind, the land (anticipating the 'vault of the sky' effect fully exploited, as we shall see, some two centuries later by Dutch artists). Most importantly, this moment in which the shadows of night are dispelled, this promise of a new day, is so much a part of our own experience, so evocative of our own real-life sensations, that it draws us into meditation both appropriate to the narrative depicted and independent of it.

For all these reasons, it is mainly the landscape that conveys and arouses emotion, and not the poses, gestures and expressions of the figures – necessary though they are as a guide to the story and our range of appropriate responses. The pleasures of landscape painting, extolled by Pliny and Alberti, are transformed by Bellini into something touching the heart more deeply.

In 1494/5 the great Nuremberg draughtsman, printmaker and painter Dürer made the first of two journeys across the Alps – the earliest German artist to look to Italy, rather than to The Netherlands, for inspiration and instruction. One of the most far-reaching consequences of this trip was the change it brought about in his attitude to landscape, as demonstrated in the small panel of *Saint Jerome* [25]. Dürer had earlier recorded individual landscape motifs, or specific locations, with dry precision. The watercolour drawings

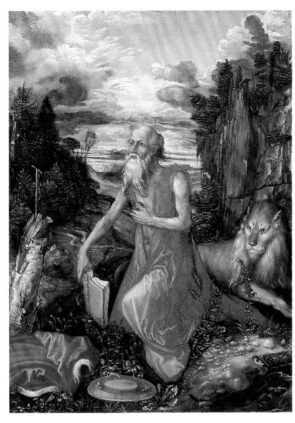

made on his way home, however, are quite different, and show his grasp of the revolution wrought by Giovanni Bellini. From topographical inventories he turned to atmospheric views, in which local colour is subsumed to the effects of light and air, and in which, as the art historian Erwin Panofsky wrote in the 1940s, 'every individual object, whether man-made or natural, is thought of as partaking of the universal life of nature'.

Although Dürer's watercolours remained private source material, he incorporated his new vision of landscape in marketable works. The most important of these were his engravings, in which Dürer suggested colour and light through filigrees of dark lines inked on luminous paper, and applied Bellini's Italian idiom to the untamed Germanic forest. His new landscape repertory of primordial firs and oaks, of Gothic pitch-roofed castles clinging to steep crags, of lone travellers lost in the trackless woods like Hansel and Gretel in the

26. Detail of 25. Grimm brothers' tale, became a source of exotic interest to southerners and of patriotic pride to Germans.

Saint Jerome, dated to just after Dürer's return to Germany in 1495, is a rare example of a Dürer oil painting combining the colour of his watercolours with the scale and spirit of his engravings. A conventional devotional picture in the way the saint and his lion are disposed in the foreground, it demonstrates all the novelty of the artist's fusion of Venetian and Germanic elements in the surrounding landscape. The panel was surely meant to be viewed like a precious jewel held in the hand, and the fascination of its vast panorama is amplified by its tiny size, which compels the eye to ever-closer scrutiny: drawing us inwards until tangled woods and dark clouds part, and an open sunlit plain ringed with blue mountains heralds Italy, the land where lemon trees bloom [26].

By the end of the fifteenth century, educated patrons were increasingly emulating the ancient Roman collectors described by Pliny in his *Natural History*, and were amassing works of art for their beauty of execution rather than for their improving subject matter. The effect is perhaps first noticeable in Venice, a centre of book-printing and engraving where writers and scholars, many of them political exiles from more tyrannical states, found refuge. Here, the status of visual artists – although still related to that of craftsmen, as elsewhere in Europe – rose enough to allow them the freedom of inspiration hitherto granted only to poets and musicians. Significantly, Bellini's pupil Giorgione was a musician as well as a painter, said to have played the lute 'so beautifully to accompany his own singing that his services were often used at music recitals and social gatherings'.

The National Gallery's *Il Tramonto (The Sunset)*, painted between 1506 and 1510 by Giorgione or a close imitator [27], shows Giorgionesque landscape at its most characteristic. Like the more famous and enig-

27. Giorgione, *Il Tramonto (The Sunset)*, 1506–10.

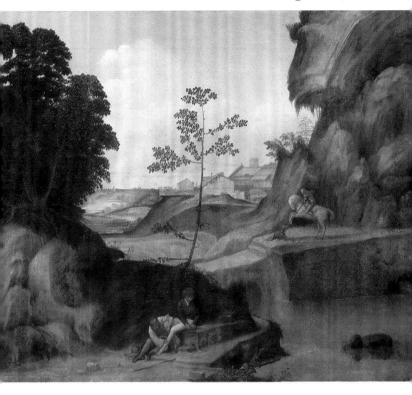

matic *Tempesta (The Storm)*, now in the Accademia in Venice, it may have been made as a secular caprice for a private collector – a more melancholy and more affecting easel version of the ancient Studius's 'sketches of people going for a stroll'. Its current appearance as a 'landscape with saints' is the result of an Italian restorer's intervention in 1933, the year the picture was discovered in a villa in the Veneto. To cover up a bare patch where paint had flaked away, he inserted Saint George killing the dragon; by modifying into a monster the rock in the centre of the lake, he also suggested that the tiny hermit in his cave is Saint Anthony harassed by demons. Following these false clues, the two nearest figures are now usually identified as Saint Roch, protector against the plague, and his friend Gothardus, who tended him when the saint himself fell victim to the disease. But the seated youth lacks Roch's normal attributes of dog and pilgrim's hat, and his companion seems less busied about an open plague ulcer in his groin than with a sprain in his calf or ankle.

These – probably anonymous – travellers set the scale, focus our attention and enlist our empathy on their voyage through a slightly magicked landscape towards a distant town. Their weary halt suggests that the sun is setting and not rising, for journeys begin in the morning and end at nightfall. The cluster of buildings beyond which the land extends to the blue horizon is still bathed in light [28], but dark shadows lengthen across the travellers' path. This alternation of light and dark wedges of paint, more than the diminution of scale, makes one plane appear to recede into the distance behind another.

The sky, in turn, is 'pushed back' by the wispy tree in the middleground, the mass of foliage on the left and the rocky outcrop on the right. Green pigment on the leaves has darkened and turned brown over the centuries, exaggerating but not radically altering the effect. The asymmetry of the two flanking elements, and their presumed continuation beyond the frame of the canvas, suggest that the landscape extends sideways as well as in depth. The height of the horizon enables us to see further than the two travellers, but the open foreground allows our gaze free entry, an unimpeded descent down a gentle incline to join them before we continue on our way together.

The travellers, our own exploration of the painting, the advent of night, draw us into a meditation on time, duration and the vicissitudes of human life, but without directing our thoughts to a predetermined narrative. It was through such pictures, which Italians called *poesie*, 'poems', as distinct from *istorie*, 'stories', that painters' kinship with freely inspired poets and musicians was most clearly recognised.

28. Detail of 27.

33

The Giorgionesque poetry of landscape in turn affected and extended the expressive range of even the most traditional genres of painting in Venetian art. An excellent example is Titian's *'Noli me Tangere'* of about 1510–15, almost certainly commissioned as a devotional picture of the penitent saint, Mary Magdalene [29]. Instead of showing the saint in a static pose with her identifying attribute of ointment jar, as was customary in Venice, Titian chose to depict the dramatic scene in the Gospel of John, Chapter 20. The Magdalen returns to Christ's burial place outside Jerusalem to find the sepulchre empty. She meets a man she mistakes for a gardener; when he calls her by name, she recognises her risen Lord. Reaching out to him, she is told, *'Noli me tangere'*, 'do not touch me'.

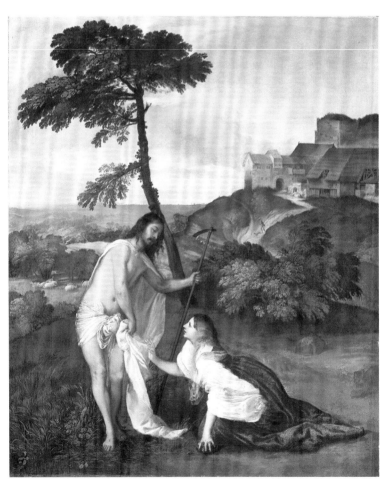

The pattern on the picture surface integrates shapes from the foreground, middleground and background, figures and landscape: the line of the Magdalen's back and of her upraised head continues through the tree into the sky, and Christ's body completes the curve of the built-up hillside. The lowly shrubs kneel to the upright tree in the middleground as the repentant sinner to the Son of God in the foreground. The flock of sheep behind Christ recalls that he is the Good Shepherd, but sheep are also the staple of pastoral poetry, and a key episode of the Christian epic is here imbued with the nostalgia of shepherds' songs of unrequited love. Repudiated, Mary's physical passion is transmuted into yearning – the never-assuaged love that is mightier than death. Through the landscape setting Titian, like Bouts [8] links the unique historic moment of the Resurrection with the recurrent seasons of nature. But he also conflates Christian with pagan sentiment, and the poetry of human love with the history of Salvation.

Printmakers in northern Europe had won the right to invent their own subjects rather earlier than Venetian artists: prints did not depend on commissions but were made for sale 'on spec'. As print production grew, traditional devotional images continued to be produced for the more popular end of the market, especially in the less technically demanding and cheaper medium of woodcut; the more discriminating new class of educated collectors welcomed novelty and could be induced to buy engravings in a wider, more ambiguous range of subjects.

Albrecht Altdorfer was, like Dürer, primarily a draughtsman and printmaker. Resident for all of his working life in Regensburg, a town on the Danube, he drew inspiration from the scenery along the river's course, as did other German and Austrian artists, notably Wolf Huber and Lucas Cranach, now collectively known as the 'Danube School'. Among Altdorfer's rare oil paintings are small works – perhaps destined for favoured collectors of his prints – in which luxuriant forest vegetation predominates. Some include human figures; a very few, like the Gallery's Landscape with a Footbridge, do not [30].

30. Albrecht
Altdorfer,
*Landscape with a
Footbridge*, about
1518–20.

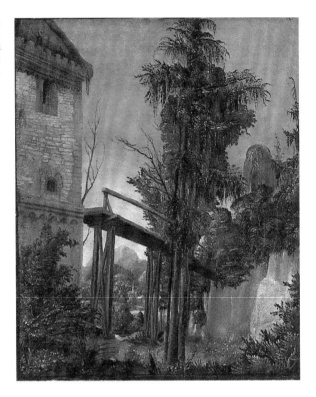

The picture was painted in oils on parchment, then mounted – we do not know by whom or when – on a wooden panel. It is vertical in format in order to emphasise the height of trees and tower and the narrowness of the watercourse. Solid and leafy forms at the sides funnel our gaze to a distant view, which the dark lines of the footbridge, made from rough-hewn logs, help to 'push back'.

The painting's greatest innovation is its consistent viewpoint from the near side of the river in the foreground. Our eyes at horizon level – marked by the church steeple nestling at the foot of the mountain range – we look upwards at the underside of the bridge and its handrail [31], at the window embrasures in the forbidding tower, at the green branches of the firs. We do not need to descend from some promontory outside the painting in order to embark on an imaginary journey within it, as we do in the *Tramonto* [27]. There, Giorgione's weary travellers elicit our empathy; in Altdorfer's *Landscape with a Footbridge* no painted surrogates are required, for the spectator is already implicit within the picture.

36

Following the example of Giovanni Bellini, painters came to understand that while human figures can convey specific emotions – fear, anger, grief, desire – landscape may evoke a less well-defined, yet equally potent range of human feelings and experience. In private pictures which could be studied closely and for a long time by a receptive spectator, scenery could even play the key expressive role. Through sagacious manipulation of space and light, the painters of 'expressive landscape' could engage the viewer in a journey as absorbing as any religious or literary narrative: a metaphor for the journey that is the story of our life, and in which our affective horizons are continuously tested and broadened.

31. Detail of 30.

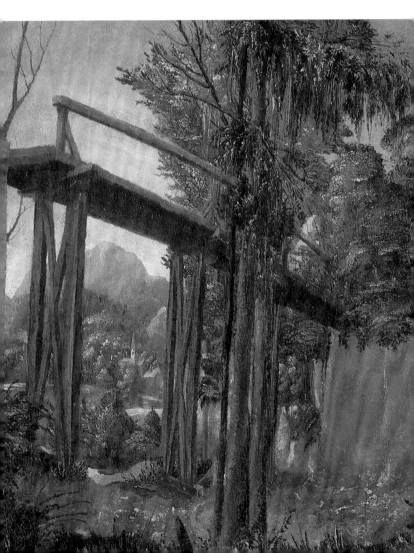

LANDSCAPE AS SPECTACLE

Renaissance collectors, through their reading of Pliny's account of the history of ancient art, also became acquainted with the notion of specialisation in painting. They began to look for contemporaries to cast in the role of the famous Greek and Roman artists whose work he described. Classically educated Italian connoisseurs enrolled north European painters – whose landscape backgrounds attracted them but whose figure style they scorned – as the modern equivalents of Studius, the inventor of landscape painting.

By the 1520s and 1530s large numbers of Netherlandish *paesi* – 'countrysides' – were being imported into Northern Italy, and the Flemish painter Joachim Patenier was acclaimed as the first modern landscape specialist. The Gallery's *Saint Jerome in a Rocky Landscape* is attributed to him [32].

32. Joachim Patenier, *Saint Jerome in a Rocky Landscape*, probably 1515–24.

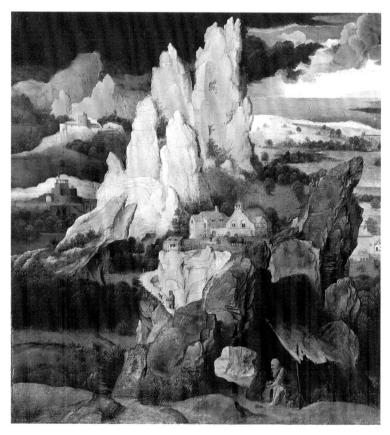

Although landscape is Patenier's main subject, his pictures are not wholly secular. They are populated by small personages from the Bible and from the *Lives of the Saints*. These figures are included, however, less to tell a story or enlist our empathy than to enable us to gauge the scale of the landscape motifs, and to lend additional interest to the vertiginous cosmic spectacle of the world depicted in all its extent and variety.

Typically for Patenier, the foreground in this panel appears more distant from the viewer than in the more intimate Venetian or Venetian-influenced expressive landscapes, and the vista extends in leaps and bounds, with many spatial dislocations, to the very curvature of the earth on the horizon. This 'world view' effect would be more clearly visible had the Gallery's picture not been cut down at the right edge, unlike the complete version of the same composition now in the Prado, Madrid.

Patenier may have been inspired by accounts of voyages of exploration and the new science of cartography, as some scholars have suggested, or he may have naively tried to emulate the savant painter described by Leonardo, 'lord' of 'great expanses'. Sincerely religious, he may even have depicted the earth as it might appear to the all-seeing eye of God. In any case, it is obvious that such pictures as the *Saint Jerome* are artificial constructs, accretions of landscape motifs that are not typical of any single region and could never have been viewed all together by anyone. The boldest eagle could not soar to the heights from which we see the mountains, the sea and the horizon, nor at the same time swoop down, as we do, to the eye level of Saint Jerome, to peep through the rock arch behind him.

Patenier's mountains [33] distantly recall the rock formations of both Leonardo and Dürer, but they remind me even more of the recipe for 'how to copy a mountain from nature' given in his *Craftsman's Handbook* by the Tuscan painter-writer Cennino Cennini in the 1390s: '... get some large stones, rugged, and not cleaned up; and copy them from nature, applying the lights and the dark as your system requires.'

Patenier's colour scheme for depicting spatial recession is also half-way between observed reality and studio artifice: warm brown tones for the immediate foreground; green for the middle distance (as in the cut-down open plain on the right); a cold blue for the furthest

background. Jerome's tunic helps to unify the painting by bringing a more saturated version of the same blue down from the top to the bottom of the panel.

The role of the new landscape specialists, such as Patenier and his followers, was similar to that of the landscape specialists of antiquity: to refresh and delight. More than the ancients, they also startled and surprised. At the same time, they codified and made available to others a set of conventions for painting landscape. Like any pictorial conventions, however, these studio tricks were gradually modified in accordance with observation of reality beyond the painter's workshop. By their obvious internal contradictions, such as the multiplicity of viewing points, they may even have encouraged artists to analyse the optical factors governing our perception of actual scenery. And the more closely the painted 'landscape as spectacle' came to resemble real landscape, the more it was able to evoke from viewers the sensations, memories and emotions associated with open-air vistas, so that the distinction between 'expression' and 'spectacle' in landscape painting was gradually effaced.

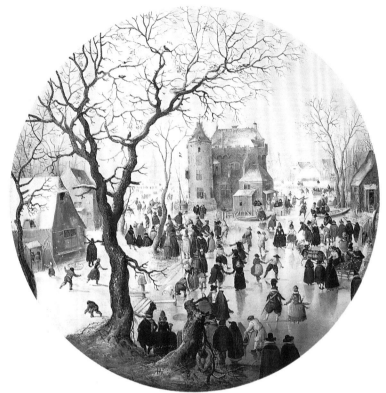

SPECTACLE
AND EXPRESSION COMBINED

SEVEN-
TEENTH-
CENTURY
FLANDERS
AND
HOLLAND

By the seventeenth century, the success of Flemish landscape specialists affected the production of art throughout Europe – nowhere more so than in the Dutch Republic founded in the northern Netherlands in 1609 after the overthrow of Catholic Spanish rule. Dutch churches were whitewashed to comply with Calvinist doctrine, and painters lost their major source of income from religious art. As contemporary scenes replaced devotional images in Protestant homes, landscape specialists proliferated, vying with each other to invent new types of view, combining various degrees of 'spectacle', realism and expressivity. One of the earliest was 'the Mute of Kampen', Hendrick Avercamp, who created the Dutch idyll of winter sports and games on the frozen rivers and canals, in which everyone, men, women and children, rich and poor, participates [34].

The wealthy Amsterdammer, Jan van de Cappelle, became the greatest painter to celebrate the might and

34. Hendrick Avercamp, *A Winter Scene with Skaters near a Castle*, about 1608/9.

41

variety of Dutch shipping in nearly monochromatic pictures which, with infinitely subtle variations of tone from light to dark, also pay homage to the monumental cloudscapes and the limpid waterways of Holland [37]. Gerrit Berckheyde from Haarlem specialised in luminous townscapes of orderly and peaceful Dutch cities [36]. Philips Koninck painted panoramic views of the uncompromisingly flat, low-lying Dutch fields, made exciting through his varied handling of paint and the patterns of shadows and sunlight cast across the land by scudding clouds [35]. Jacob van Ruisdael became the interpreter of melancholy woodlands [38] and ruins of Holland's feudal past [58]. These are only a few examples from among the innumerable Dutch landscape pictures in the Gallery and elsewhere. Hobbema's *Avenue at Middelharnis* [55], discussed on page 56, brought to a close nearly a century of perhaps the most ingeniously diverse views ever painted.

Influential though these Dutch 'Little Masters' became, their example was less important to the later evolution of landscape painting than that of Rubens – especially in England, where most of the landscapes executed by this illustrious figure painter for his own enjoyment found their way after his death.

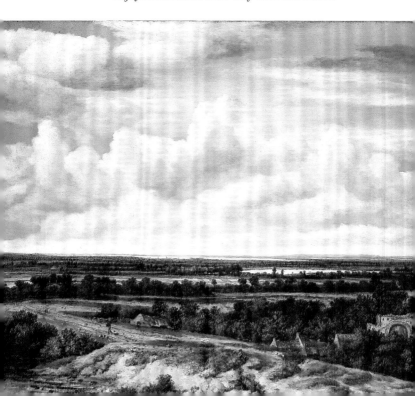

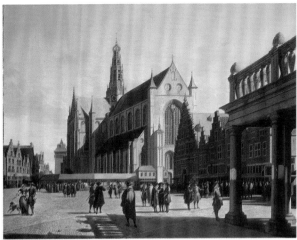

36. Gerrit Berckheyde, *The Market Place and the Grote Kerk at Haarlem*, 1674.

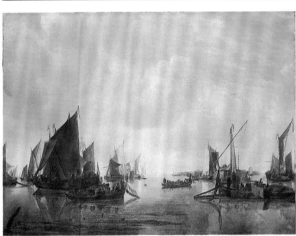

37. Jan van de Cappelle, *A River Scene with Dutch Vessels Becalmed*, about 1650.

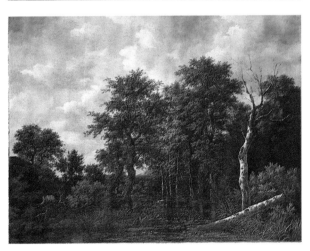

38. Jacob van Ruisdael, *A Pool surrounded by Trees & Two Sportsmen coursing a Hare*, about 1665.

One of the Gallery's most celebrated works, Rubens's panoramic *Autumn Landscape with a View of Het Steen in the Early Morning* of 1636 [40], adapted Patenier's world view to real scenery, and flooded Flanders with sunlight imported from Venice.

The *Landscape with Het Steen* was almost certainly painted – with its companion, the *Landscape with a Rainbow* now in the Wallace Collection, London [39] – for the manor house of the country estate Rubens bought in 1635. Like Patenier's little *Saint Jerome* [32] Rubens's enormous panel, with its high horizon line, resolves into multiple vignettes, each with its own viewing point. Its colour scheme also ranges from warm browns and reds in the foreground, through a middle-ground of green to a cool, airy, blue background. The unity of the whole, however, is ensured through fidelity to natural appearances, a play of light and shadows consistent with the position of the rising sun, and a vibrant, lively paint surface. Although a greater expanse of land is depicted than the artist could ever have surveyed from any single point, the view is real, representing Rubens's estate with house and tower on the left, and the meadows and copses of the flat Brabant plain beyond [41]. The picture is orientated like a modern map; the sun rises on our right, and we look northwards to the town of Malines on the horizon. In the companion *Landscape with a Rainbow* [39] the

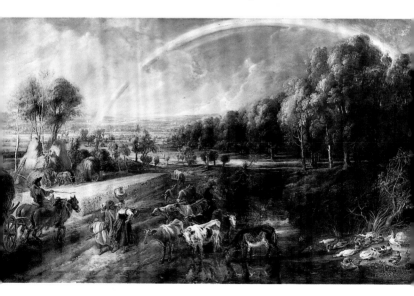

44

sun sets on our left. Hung on facing walls, the two paintings replicate the course of a single summer's day.

The purchase of his country estate marked Rubens's retirement from public duties; it also elevated his family into the landed gentry, as the estate brought with it the title of Lord of Steen. The activities depicted within each painting represent, in an affectionately idealised form, the peaceful and orderly cycle of life on the Lord of Steen's fruitful estate, at harmony with the laws of nature and society. Nor is God forgotten: the rainbow in the Wallace Collection picture recalls his 'bow in the cloud', set for the first time after the Flood as a sign of his covenant with Noah 'and every living creature...for perpetual generations', God's 'covenant with the earth' (Genesis 9:12, 13).

Such gratefully boastful country-house decoration was sanctioned by the ancient Romans – as Rubens, a proficient classical scholar, well knew – and by modern Italians, among whom he had lived. Paradoxically, then, these rural Flemish landscapes, hinting at the artist's piety, also demonstrated his classical and Italianate culture. At the same time, since many details are loosely based on Rubens's drawings from nature, while peasants and dairy maids recall figures by Pieter Bruegel, Patenier's greatest sixteenth-century Flemish follower, the pictures also proclaimed Rubens's affection for his native land and its pictorial tradition.

40. Peter Paul Rubens, *Autumn Landscape with a View of Het Steen in the Early Morning,* probably 1636.

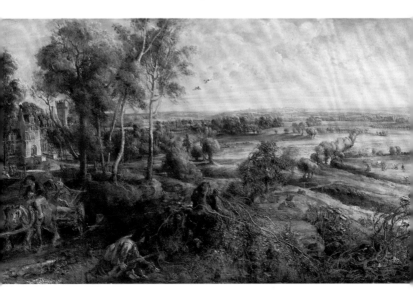

41. Detail of 40.

Finally, through his authorship of these great panoramas, Rubens was able to reaffirm his belief in the nobility of artistic creation, truer than any secular title: 'if [the painter] wants to disclose great expanses of countryside...he is lord of them'.

The paintings also evoke viewers' actual experience of the passage of time. As the *Landscape with Het Steen* is so large, we are able to see the whole of it only from a distance. But there is no satisfactory viewing point at which we can rest. Oversize details, like the partridges near the foreground, draw us to the copious incidents depicted, and to view these we must move closer to each: so close that we can no longer see the painting as a whole. Walking backwards and forwards, scanning the picture surface while trying to reconcile incompatible views near and far, to make detailed discoveries while encompassing the immensity of the space

traversed by the sun's rays – all this takes time, and the physical effort of taking imaginative possession of this landscape makes us conscious of the time it takes.

A year before Rubens painted the *Landscape with Het Steen*, he wrote to a friend,

'Having renounced every sort of employment outside of my beloved profession... I am leading a quiet life with my wife and children, and have no pretension in the world other than to live in peace.'

We can read this magisterial landscape and its companion as Rubens's domestic paean to peace, even more deeply felt than the allegory of '*Peace and War*' he painted for Charles I and which is now also in the National Gallery.

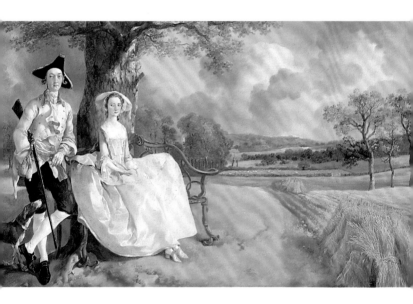

Gainsborough's love of the Suffolk countryside is well attested in early works such as his 1748 marriage portrait of *Mr and Mrs Andrews* improbably posed in the fields of Auburies, their farm at Sudbury [42]. In these small pictures, however, the landscape, despite its lyricism and veracity, remains secondary, a topographical allusion to the sitters.

An autonomous landscape begun in the same year, '*Cornard Wood*' [43], reinterprets Suffolk scenery in what Gainsborough called the 'little Dutch' style of Ruisdael. It is only with the more monumental and

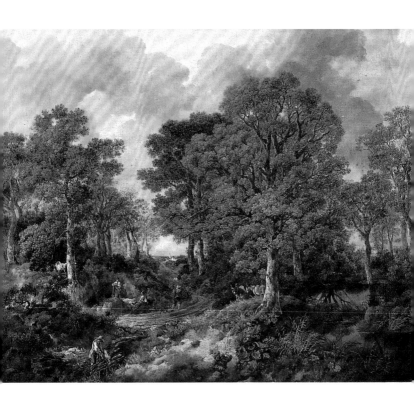

43. Thomas
Gainsborough,
'Cornard Wood',
about 1748.

44 (opposite).
Thomas
Gainsborough,
*The Watering
Place*,
about 1774–7.

45. Peter Paul
Rubens, *The
Watering Place*,
about 1615–22.

dramatic *Watering Place*, exhibited in 1777 [44], that Gainsborough's landscape attracted critical praise in its own right – thanks to the influence of Rubens's picture of the same name, seen by Gainsborough in the collection of the Duke of Montagu and now also in the Gallery [45]. Both are dominated by trees clinging to a Pateniresque rock; in both, cattle descend to a watering place half in light, half in shade, reflecting their forms and the dark foliage. Both allow glimpses through the trees into the distance, and both show reclining figures in pastoral leisure. 'Gainsborough's larger landscape', exclaimed a contemporary critic, 'is inimitable. It revives the Colouring of Rubens in that line.' Another was even more emphatic in the annotation of his catalogue: 'In the style of Rubens and by far the finest landscape ever painted in England and equal to the great masters.'

Rubens's truest heir, however, was Constable, who studied the *Landscape with Het Steen* [40] in the collection of his patron, Sir George Beaumont, the earliest benefactor of the National Gallery. In lectures

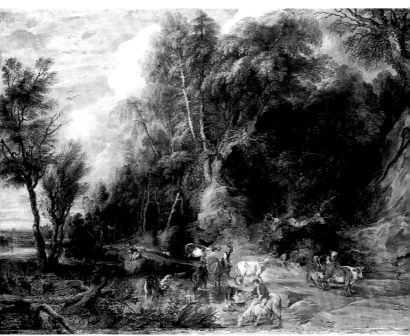

49

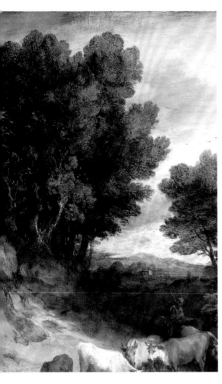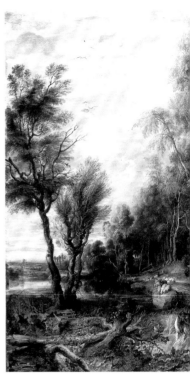

46. Detail of 44.
47. Detail of 45.

delivered at Hampstead in 1833, Constable singled out 'the freshness and dewy light, the joyous and animated character which [Rubens] has imparted to [landscape]'. His own *Hay-Wain* [49] emulates the *Landscape with Het Steen* not only in the motif of the cart crossing the stream, in its large size and the sparkle of its paint surface, but also by raising a much-loved native landscape into the stately stuff of art.

More than Rubens, Constable strove simultaneously to show and to conceal his art. Although traces of the Flemish tripartite colour scheme survive in the warm, red-accented brown of the foreground, the *Hay-Wain* is no cosmic panorama glided over by some disembodied spectator. Constable depicts an intimate corner of Suffolk from a single, unifying point of view near the centre of the picture – inviting us to stand beside him on the left bank of the mill stream of the River Stour near Flatford Mill, of which his father had the tenancy. The house on the left is farmer Willy Lott's cottage; the focus of attention is a hay-wain moving away from us through the water, watched by a black

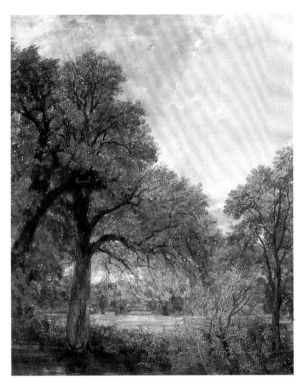

48. Detail of 49.

49. John
Constable,
The Hay-Wain,
1821.

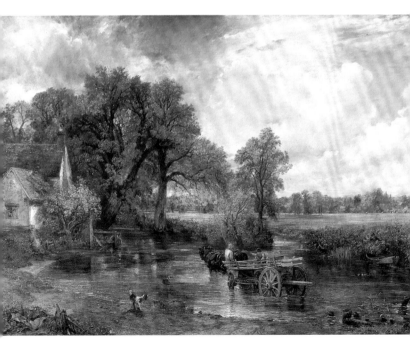

and white dog wagging his tail. The effect sought is one of immediacy and homely familiarity, at odds with the monumental scale of the canvas.

Yet despite its seeming truthfulness to the real location and the unique moment, the picture is a synthetic artefact of Constable's London studio, laboriously assembled in the winter months from a mass of disparate drawings and oil sketches executed after nature during summers in the country, many of them years earlier. Clouds – in which Constable the miller's son had a particular interest – were studied separately during 'skying' expeditions. The harvest wagon itself is derived from a sketch made, at Constable's urgent request, by his friend and assistant John Dunthorpe, who 'had a very cold job' drawing it in Suffolk in February.

As the self-taught Constable had extreme difficulty in forging a coherent whole from such a wealth of observations, he often painted full-size trial canvases of his exhibition 'six-footers' – a time-consuming and expensive procedure. The full-scale oil sketch for the *Hay-Wain*, now in the Victoria and Albert Museum, includes a figure on horseback in the foreground, which Constable introduced in the final picture, then replaced with a barrel at the edge of the stream. This in turn was painted out (but is now becoming visible again, as the oil paint on the surface becomes translucent with age).

Constable's success in preserving, through such arduous effort, the appearance of spontaneity and the 'joyous and animated character' of Rubens's landscape vision may be gauged from viewers' reactions to the *Hay-Wain*. When it was exhibited, under the title *Landscape: Noon*, in Paris in 1824, French painters and critics singled out its 'richness of texture, and attention to the surface of things. . . [its] truth. . . vivacity and freshness.' For the English and for anglophile tourists, it has achieved the status of an icon: barely a man-made painting but the instantaneous reflection, in nostalgia's wishful mirror, of an abiding rural England in all the beauty of its summertime.

While Constable was celebrating Rubensian summer in England, his German contemporary, Caspar David Friedrich, was exploring an alternative tradition harking back to Dürer [50]. In this meticulous

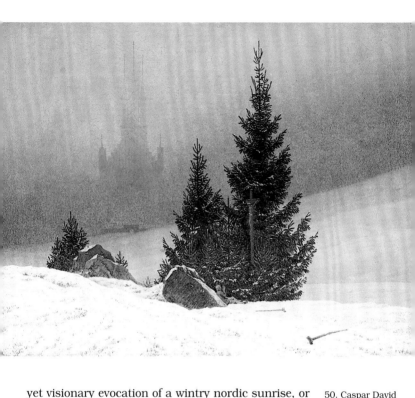

yet visionary evocation of a wintry nordic sunrise, or sunset, the ghostly silhouette of a Gothic church rises out of the freezing mist, echoing the living forms of fir trees in the foreground. The tiny figure of a man has abandoned his crutches in the snow, through which fresh shoots of grass push upwards. His hands are folded in prayer before the wooden crucifix set among the evergreens. A companion picture, still in Germany, depicts him hobbling desolately across a snow-bound landscape of dead and dying oaks. Its bleak despair is countered by the London image, which signals winter's end and likens the reawakening of nature to the Christian's hope of salvation and eternal life.

The painting's symbolism is akin to that of Bouts's *Entombment* [8], but it is no longer dependent on a biblical narrative. It is embedded within the landscape itself – its light and weather conditions, the fanciful yet not impossible proximity of a great medieval church, the actions of an anonymous traveller – and the feelings and associations these arouse in the viewer: that conflation of 'spectacle' and 'expression' which, I believe, is the hallmark of modern landscape easel painting.

50. Caspar David Friedrich, *Winter Landscape*, probably 1811.

THE OPTICS OF
LANDSCAPE

The landscape painter must, as I have stressed, represent extensive yet continuous space and outdoor light: the natural light of sun or moon, at times augmented by artificial illumination.

Perhaps the most complex illumination ever painted is found in Elsheimer's dramatic night scene of *Saint Paul on Malta* of about 1600 [51], in which the shipwrecked saint and his companions are comforted by the natives of the island (Acts of the Apostles, 28: 2–3). Depicted on a copper plate hardly bigger than my hand, this immense landscape enlists moonlight, flashes of lightning, a fiery distant beacon [52] and foreground bonfires to depict the terrifying might of nature and the benign workings of Providence.

Painters represent outdoor space and light by manipulating the factors that condition our perception of them in reality. These can be summarised as: linear perspective and the spectator's point of view; the source, direction and temperature of light, and aerial perspective. I shall also discuss the way certain motifs seem to 'push back' sky or distant land (repoussoir), and picture format. We have met many of these ideas and terms in the preceding chronological survey.

51. Adam Elsheimer, *Saint Paul on Malta*, about 1600.

52. Detail of 51.

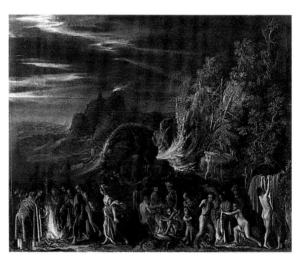

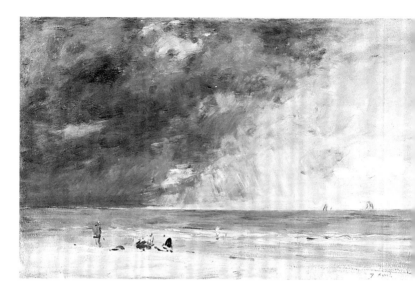

LINEAR PERSPECTIVE

THE
HORIZON LINE

In nature, the horizon line where the earth meets the sky corresponds to our eye level. Remember, for example, what you see in the distance when you lower your eye level by sitting on the beach: a great deal of sky, but much less sea and land [53].

You need to climb a skyscraper or a mountain to raise your eye level and the line of the horizon. Your effort will be rewarded with an extensive panorama, as more land than sky stretches in front of you [54].

RECESSION
AND THE
VANISHING
POINT

If you stand on railway tracks or a straight road leading away from you to the horizon, the receding parallel lines seem to draw together and meet at a point on the horizon (the vanishing point) exactly opposite to your viewing point. At such great distances it doesn't matter that you are using both eyes instead of just one, as you must to see the smaller-scale perspectival construction of a peep show. The most familiar method of pictorial construction, described by Alberti in 1435, postulates a single vanishing point in the centre of the image. This is the method adopted by the Dutch seventeenth-century painter Hobbema in his famous picture of an actual road lined with trees, the *Avenue at Middelharnis* of 1689 [55].

53. Eugène Boudin, *Beach at Trouville*, probably 1890s.

54. Théodore Rousseau, *The Valley of St-Vincent*, probably 1830.

56

55. Meinert Hobbema, *The Avenue at Middelharnis*, 1689.

56. Francesco Guardi, *An Architectural Caprice with a Palladian Style Building*, 1770s.

A more dramatic diagonal effect is obtained by placing a single vanishing point at the side of the painting [36], or by using two lateral vanishing points [56], as counselled in a refined version of Alberti's method published in 1505 by Jean Pélerin, called Viator.

DIMINUTION

Figures or objects along receding tracks or roads seem to diminish gradually in size. The smaller they appear, the further away they must be. Hobbema brilliantly exploited this effect in the *Avenue at Middelharnis* [55]. By placing the head of the hunter walking along the avenue at the exact vanishing point on the horizon, Hobbema makes it seem that the small painted figure is advancing directly towards the viewer, at the same eye level. Viewer and hunter must meet in due course.

But you don't need receding lines to see perspectival diminution: things simply appear smaller the further they are from you. An ocean liner at the horizon appears no bigger than a child's toy boat near the

shore. My baby daughter once cried because I wouldn't bring a helicopter down from the tree for her to play with. She knew the buzzing, bobbing object was out of her reach, but she couldn't tell by how far, because she didn't yet know how big helicopters are. Since we are most familiar with the size of human beings, figures of people are useful indicators of recession in space. In this study for a larger canvas of *Summer* by the nineteenth-century French painter Puvis de Chavannes [57], the diminishing scale of men, women and children is the main clue to the distance between the pond in the fore-ground and the ripe wheat in the middleground.

57. Pierre-Cécile Puvis de Chavannes, *Summer*, before 1873.

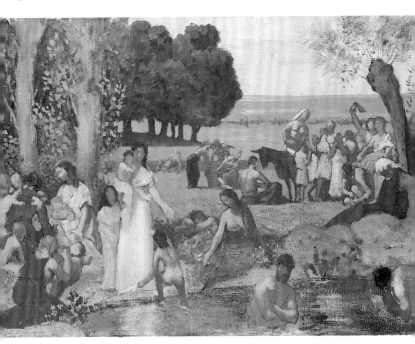

Clouds, like any other thing, are subject to the laws of linear perspective. 'Streaky clouds at the bottom of the sky' (a notation by Constable) may appear parallel to the horizon. But fat cumulus or nimbus clouds may seem to swell over our heads and get smaller or nar-rower in the distance. This was the discovery that enabled Dutch seventeenth-century painters (who had good damp cloudscapes before their eyes every day) to depict the sky as a rounded 'vault' rather than a flat backdrop. We see the effect in, for example, Ruisdael's

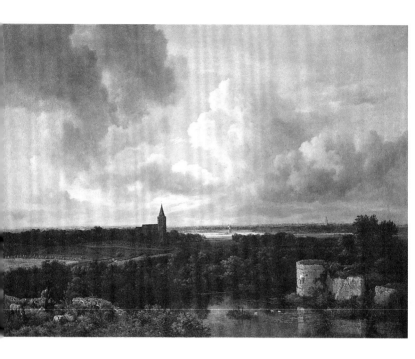

58. Jacob van
Ruisdael,
*Landscape with a
Ruined Castle
and a Church*,
about 1665–70.

Landscape with a Ruined Castle and a Church [58]. Constable's open-air study of *Weymouth Bay, with Jordan Hill* [59] probably painted on the artist's honeymoon in 1816, owes as much to its Dutch predecessors as to direct observation.

RECESSION,
DIMINUTION
AND THE
VIEWER'S
LOCATION

Because all the pictures so far reproduced concentrate on the faraway, they situate the spectator at some distance from the landscape. Even Constable's *Weymouth Bay* [59], which shows nearby stones and pebbles, does not place them at the viewer's feet. As the German artist Sandrart, who accompanied the great seventeenth-century landscape specialist Claude Lorrain on his sketching trips to the Roman countryside, noted: '[Claude]...only painted...the view from the middle to the greatest distance'.

59. John
Constable,
*Weymouth Bay,
with Jordan Hill*,
probably 1816.

I shall return to Claude and the rest of this quotation presently. First, let us look at a picture which in a more realistic way closes the gap between the viewer and the view: Monet's *Bathers at La Grenouillère* [60].

60. Claude
Monet, *Bathers
at La Grenouillère*,
1869.

How does Monet manage to include a nearby foreground – the interior of the rowing boats-for-hire bobbing in the water – as well as 'the view from the middle to the greatest distance'? Part of the answer is that the

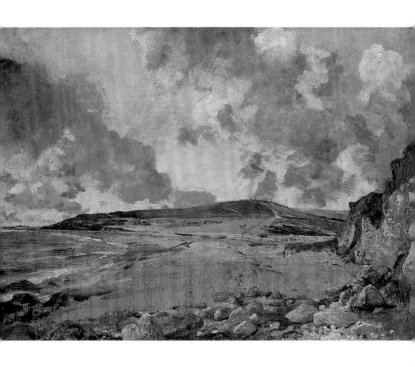

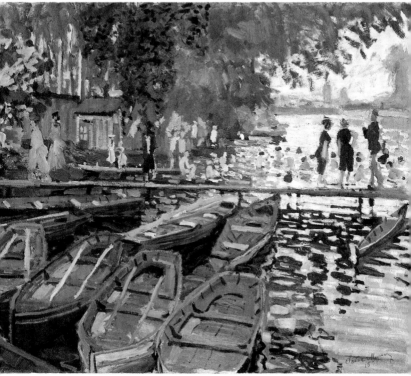

61

frame cuts off our view of the boats on the left and at the bottom of the picture, and of the river widening on the right, implying that we are shown only a detail of a greater whole – a 'close-up'. The diminution in scale from the boats to the figures on the wooden walkway is too abrupt, but this is concealed by the dazzle of reflected sunlight which seems to consume these figures as we look at them – an effect made possible by the broad, summary brushstrokes with which Monet painted the entire scene, using newly invented ferruled flat brushes. But the even more abrupt shift in scale, from the figures to the buildings in the background, is made believable by a traditional device (see, for example, 23 and 24). The river (which we naturally take to be a continuous flow of water) seems to curve around and disappear out of sight behind the projecting wooded bank on the left, before reappearing further away – slowing down its course to the horizon, and seemingly expanding the space from middleground to background.

LIGHT AND AERIAL PERSPECTIVE

Monet's summer glitter serves to introduce the topic of light. I've already quoted Leonardo's observations on aerial perspective. Any viewer of his *Virgin of the Rocks* [9] will readily see that the grotto enframing the Virgin and her companions creates two separate light sources: one illuminating the figures in the foreground, which falls from above and outside the painting, and a second one shining from within the panel to light the rocks and the water in the distance.

A dual lighting system of this kind bedevilled landscape painting for a long time, usually without the optical justification of a rock arch. Even in Bellini's *Agony in the Garden* [24] a separate spotlight seems to fall on Christ and the disciples. The nocturnal bonfires that illuminate the foreground figures in Elsheimer's *Saint Paul on Malta* [51] seemingly – though not in actual fact – enabled the artist to dispense with this illogical device.

The first artist to resolve the problem consistently, and to achieve unity of light within a unified space, was Claude Lorrain. Sandrart's description of Claude's work continues:

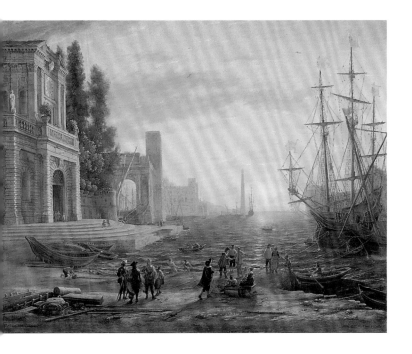

*[Claude]...only painted, on a small scale, the view
from the middle to the greatest distance, fading away
towards the horizon and the sky...[he is an example to
all artists] of how one can order a landscape with
clarity, observe the horizon and make everything
diminish towards it, hold the colouring in proportion
with the depth, each time represent recognisably the
time of day or the hour, bring everything together in
correct harmony by accentuating strongly the front and
shading off the back in proportion...*

61. Claude, *A
Seaport*, 1639.

The novelty of Claude's procedures, and the acute-
ness of Sandrart's analysis, can be demonstrated in
A Seaport of 1639 [61], one of the Gallery's twelve paint-
ings by the artist. The disc of the sun – the lightest in
tone and thus apparently the most brilliant area of the
canvas – is positioned virtually to coincide with the van-
ishing point, to which the receding edges of the archi-
tecture draw our gaze. The trail of the sun's reflection
on the water and the long shadows of the figures in the
foreground reinforce the linear perspective. The sun-
facing surfaces of buildings, figures, foliage, clouds and
masts are either painted in a lighter tone or edged with
gold, to appear raked with sunlight.

We may well believe that Claude, like his friend Poussin, built toy theatres that he lit with a single candle to study the fall of light – but perhaps he relied only on the many outdoor sketches that he brought back to his studio from his excursions to the countryside around Rome and the Bay of Naples. From the sun's position in this picture, and its warm reddish light, we can deduce that it is either sunrise or sunset. A clock on the nearest building (hardly visible in reproduction) gives the time as five o'clock. The clock's hands and the full foliage of the trees suggest a summer sunrise... although I always think of this as a sunset picture; Claude's early-morning paintings of embarkations are usually brighter and cooler.

As the size of objects diminishes in the distance, so their colours become desaturated, progressively diluted with the same creamy white used to paint the sun: the pure red accents of the foreground, for example, turn to brick-rose and dun in the background. What is true for hues is equally true for tonal values: the ship nearest us is darker than the one behind it. That is what Sandrart means by 'hold[ing] the colour in proportion with the depth...accentuating strongly the front and shading off the back'. Because Claude does not here translate the effects of aerial perspective into cool blue tints, the warm tonality of the 'hour of the day' is preserved throughout the painting.

REPOUSSOIR

Now look at the tall poplars silhouetted against the sky on the left of Claude's *Seaport* [61], and the tracery of dark masts on the right [62]. Such dark upright forms, visibly rooted in the middleground or the foreground of a painting and rising towards the top against a lighter background, seem to 'push back' the latter – hence the word *repoussoir*, from the French verb *repousser*, to push back.

The sixteenth-century Italian writer Aretino, Titian's friend and publicist, was well aware of this effect when he noted of an actual view from his window,

Oh, with what beautiful strokes did Nature's brush push back the air, making it recede from the houses just as Titian does when he paints a landscape!

63. Claude, *Landscape with Hagar and the Angel*, 1646.

Claude's *Landscape with Hagar and the Angel* of 1646 [63] relies on *repoussoir* trees and foliage to frame and help 'push back' the distant view. This little painting, like Rubens's *Landscape with Het Steen* [40], once belonged to Sir George Beaumont, as we learn from C.R. Leslie's *Memoirs of the Life of John Constable*:

Mrs.Constable procured for her son [John] an introduction to Sir George Beaumont, who frequently visited his mother, the Dowager Lady Beaumont, then residing at Dedham…and at the house of the Dowager Lady Beaumont the young artist first saw a picture by Claude, the 'Hagar', which Sir George often carried with him when he travelled. Constable looked back on the first sight of this exquisite work as an important epoch in his life. . . as Constable had till now no

opportunity of seeing any pictures that he could rely on as guides to the study of nature, it was fortunate for him that he began with Claude...

The lasting influence of Claude's little *Hagar and the Angel* can be seen in Constable's much-loved *Cornfield* [64], painted five years after the *Hay-Wain* [49], and presented to the National Gallery by subscribers in 1837, the year of the artist's death. The picture adapts Claude's composition to a view of Fen Lane, which led through trees from Constable's birthplace, East Bergholt, to a cornfield and the village of Dedham in the distance. The vertical format enabled Constable, like Claude before him (and Altdorfer earlier [30], Cézanne later [2], to stress the height of the trees, while funnelling our gaze between them to the luminous view

64. John Constable, *The Cornfield*, 1826.

65. Detail of 63

66. Claude,
*Seaport with the
Embarkation of
the Queen of
Sheba,* 1648.

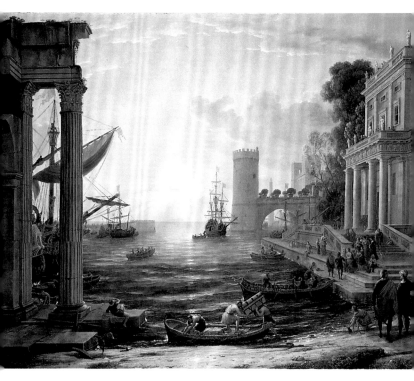

beyond. But where Claude evokes nostalgic memories of times past, in the Roman bridge and the medieval hill town delicately fading into air in the background, Constable's sunlit prospect is robustly of the present moment. He also titled this picture *Landscape: Noon* for exhibition, attaching to it lines from James Thomson's poem, *Summer*, published in 1727: 'while now a fresher gale, sweeping with shadowy gusts the fields of corn...'

Claude's influence on Constable's more flamboyant rival, Turner, is even more evident. Turner's *Dido Building Carthage, or The Rise of the Carthaginian Empire* of 1815 [67] was as much homage as challenge to Claude's seaport pictures, and in his will Turner specified that it be hung in the Gallery together with his seventeenth-century predecessor's *Seaport with the Embarkation of the Queen of Sheba* [66]. By exaggerating the tonal contrasts between dark *repoussoir* features and the light background, and between dazzling reflection and dark shadows on the water, Turner shatters Claude's pictorial harmony, transforming epic into melodrama.

67. J.M.W. Turner, *Dido building Carthage*, 1815.

More surprisingly, perhaps, Turner's famous meditations on time and human destiny, in the guise of landscapes of modern life, *The Fighting Temeraire, tugged to her last berth to be broken up, 1838* [69], and *Rain, Steam and Speed – The Great Western Railway,* exhibited in 1844 [70], also borrow from Claude's serene art, adapting his subtle devices to vehement and dramatic ends. In the *Temeraire*, the black silhouette of the tugboat 'pushes back' the sailing ship, making it seem even more spectral [68], and the setting sun recedes redder and more luminous by contrast with the dark buoy below it. In *Rain, Steam and Speed*, the harsh, black, iron locomotive and its flaring light rush forward, along the exaggeratedly receding tracks of the viaduct spanning the Thames between Taplow and Maidenhead.

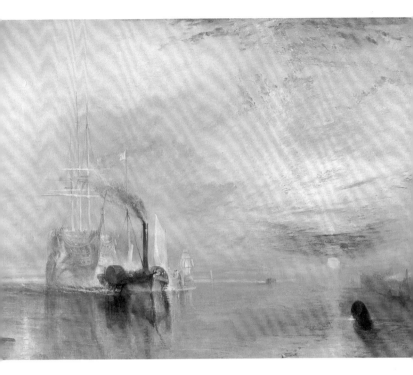

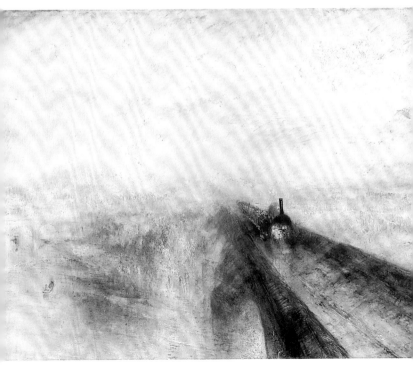

IMPRESSIONISM
AND AFTER

REJECTION OF THE OLD MASTERS?

'To paint in the open air, as one feels and as one sees, without thinking of anyone, either old masters or the public, is without doubt the way to assure one's own originality', wrote the French critic Théophile Thoré in 1866.

The outdoor, or *plein-air* painting of the French 'Impressionists' (originally a term of disparagement coined by a hostile critic) was made possible by the availability of new artists' equipment, such as the collapsible metal tube, which ensured the permanent availability of fresh oil paint. Of course, the Impressionists were not the first to work in the open air. Claude had sketched from nature out in the Roman Campagna, and by 1800 the practice was well established as part of the training of artists. Most painters, however, continued to retain the distinction between rapid open-air studies and the more elaborate studio compositions for which these served as raw material. Even Corot, now revered for his luminous small oils painted rapidly in front of the motif during innumer-

71. Camille Corot, *The Roman Campagna with the Claudian Aqueduct*, probably 1826.

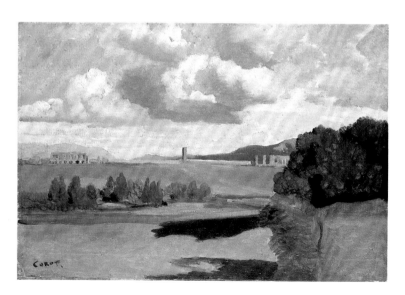

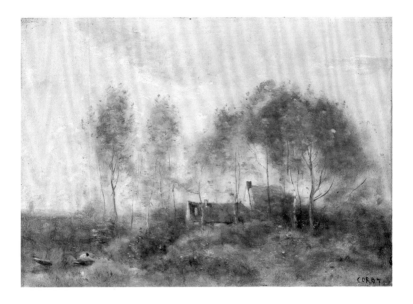

able dedicated sketching trips – such as the heat-seared *Roman Campagna with the Claudian Aqueduct* executed in Italy in 1825–8 [71] – rarely exhibited such works. Early in his career he emulated the idealised landscapes of Claude and Poussin, 'correcting' the defects of nature in the studio and adding edifying narratives. From the 1850s, he relied increasingly on memory to create lyrical 'souvenirs' appealing more directly to the viewer's emotions [72]. In reaction to such increasingly stereotypic confections, Emile Zola, famous champion of 'realism' in literature and art, wrote – also in 1866: 'I prefer a thousand times a *pochade* [a very free, bold, rapid sketch], an *esquisse* [a sketch, less imprecise than a *pochade*] painted by [Corot] in the open countryside, face to face with the powerful reality'.

Pronouncements such as Thoré's and Zola's were perhaps even more challenging than the advocates of artistic spontaneity intended. By devaluing the imaginative and intellectual effort required to 'work up' a picture to the traditional degree of idealisation and finish, they virtually demoted the artist to a receptor and transmitter of sensory impulses from 'powerful reality'. In this view, the 'originality' adduced by Thoré was largely defined by the artist's choice of contemporary subject matter: industrial, urban and suburban sites, parts of the countryside made accessible by the modern railway.

72. Camille Corot, *Souvenir of a Journey to Coubron*, 1873.

The aesthetic revolution advocated by the 'realists' was not, however, immediate or complete. Even Monet's *Bathers at La Grenouillère* [60] was painted in 1869 as a study for a more highly finished picture – he called it a 'bad *pochade*'. Only in 1874, exhibiting with the newly formed dissident Society of Artists, did Monet dare to show a sketchy view of the port of Le Havre. Now in the Musée Marmottan in Paris, this picture, entitled *Impression, Sunrise*, earned the Society the contemptuous sobriquet of 'Impressionists'. For some years Monet and his colleagues attempted to capture fugitive effects of outdoor light and weather as they occurred, defining form and space only through contrasts and nuances of colour. New developments in colour theory and paint technology came to their aid. Renoir's *Boating on the Seine* of about 1879–80 [73], for example, successfully evokes the brilliance of strong sunlight thanks to the newly synthesised pigments, cobalt blue and chrome orange, used unmixed as they came out of the tube. The choice of colours was dictated by the 'law of simultaneous contrast' proposed by the dye chemist

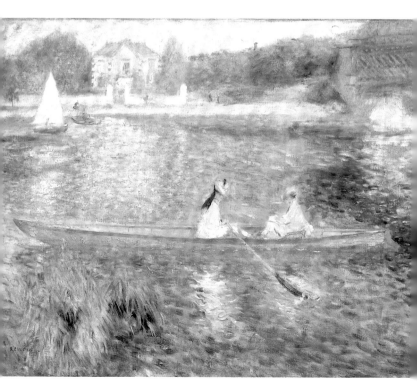

Chevreul in 1839, which states that colours opposite each other on a colour circle – the so-called 'complementaries', blue and orange, violet and yellow, red and green – are enhanced in intensity when juxtaposed.

But there were practical problems, which caused even the most dedicated Impressionist to compromise the ideals of immediacy and spontaneity by completing or adjusting pictures in the tranquillity of the studio. Light and weather conditions changed constantly, motifs altered their position as well as their appearance, sunstroke, wind, wasps, mad bulls and hecklers intervened. In addition to these, however, there was a more fundamental impediment to painting 'as one sees and as one feels, without thinking of...old masters'. For, in the end...

...THE OLD MASTERS HAVE THE LAST WORD

Painting itself is not a spontaneous activity, but implies awareness of an age-old tradition. Easel pictures in particular are conventional objects, with a surface, size, shape and borders that any arrangement of forms and colours must take into account. Even leaving aside the cultural conditioning that enables one to seek aesthetic pleasure in scenery, the very notion of excerpting 'a motif' from boundless three-dimensional reality involves knowing there are such things as landscape paintings. And a trained artist (especially one who, like the Impressionists, has frequented picture galleries) cannot but be aware of the representational solutions already proposed to all those problems of the 'optics' of landscape outlined above. Even the most spontaneous and original *plein-air* painter will therefore, consciously or not, tend to set up an easel where reality itself fits a preconceived idea of a picture.

Monet's fascination with depicting the city's legendary fogs on his first visit to London in 1870–1, need not, perhaps, have been sparked by Turner's paintings [70]. What is certain is that his *Thames below Westminster* [74] betrays knowledge of Turner, and, even more crucially, Claude. He has looked at the modern city in the spirit of those eighteenth-century travellers who gazed at choice prospects in a tinted

74. Claude Monet, *The Thames below Westminster*, about 1871.

convex mirror called a Claude glass. With its diffused light emanating from the sky in the background, its *repoussoir* motifs, its single vanishing-point and aerial perspective, Monet's 'spontaneous record' of fleeting appearances is firmly rooted in seventeenth-century pictorial formulae.

The Impressionists' link with tradition goes back, however, well beyond the seventeenth century, and is surely one reason for their relatively ready acceptance in their lifetime and their popularity today. When Monet depicted bathers at La Grenouillère [60], and Renoir young women boating on the Seine [73] they were, in truth, like so many Impressionist painters, emulating Pliny's Studius, 'who first introduced the most attractive fashion of painting... pictures... of people going for a stroll or sailing in a boat'. But in this link with the earliest traditions of landscape painting there lies also the seed of artists' reaction against Impressionism. For if Impressionist landscapes refreshed and delighted their bourgeois clientele, they also aroused artists' perennial fear of being thought shallow and frivolous. Fleeting pleasures and momentary sensations are only some of the innumerable themes with which painting can engage, and fugitive effects but one aspect of nature.

And so once more to art, the iconoclastic art of the twentieth century. When Richard Long photographs the line he walked in Peru, and Christo a stretch of Australian coastline wrapped in nylon, or Claes Oldenburg draws a humble clothes peg from a low view point to straddle the horizon like a colossus [77] – their 'statements' provoke or cajole because of their kinship with traditional landscape imagery.

Landscape fulfils Oldenburg's call 'for an art that... does something other than sit on its ass in a museum... that embroils itself with the everyday crap & still comes out on top.' In a seemlier age, the Royal Academician Henry Fuseli put it differently – as reported by Constable in a letter that wickedly transcribes Fuseli's heavy German accent: 'I like de landscapes of Constable, he is always picturesque, of a fine colour, and de lights always in de right places; but he makes me call for my greatcoat and umbrella.'

It is this perennial, willed confusion between art and life that ensures landscape painting's continuing hold on our affections.

77. Claes Oldenburg, *Late Submission to the Chicago Tribune Architectural Competition of 1922: Clothespin (version 2)*, 1967. Des Moines Art Center Permanent Collection.

FURTHER READING

A great deal has been written about landscape painting and the individual artists who have practised it. Some of the most useful and readily available texts are:

K. Clark, *Landscape into Art*,
 London, 1949; repr. 1979.

E. H. Gombrich, 'The Renaissance Theory of Art and the Rise of Landscape', in *Norm and Form*, Oxford, 1985.

'Landscape Painting', *The Dictionary of Art*,
 ed. J. Turner, London, 1996.

C. R. Leslie, *Memoirs of the Life of John Constable*, London, 1843; repr. 1995.

The following National Gallery exhibition catalogues include full bibliographies:

Art in the Making: Impressionism,
 D. Bomford, J. Kirby, J. Leighton and A. Roy, 1990.

Making and Meaning: Rubens's Landscapes,
 C. Brown, 1996.